Tenancy

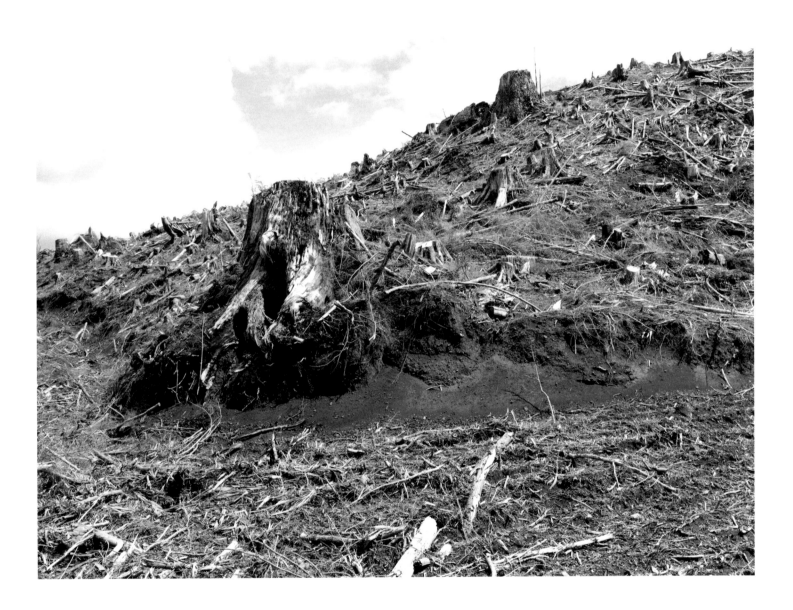

ROBERT ADAMS

Tenancy

BETWEEN THE RIVER AND THE SEA

THE NEHALEM SPIT, THE COAST OF OREGON

FRAENKEL GALLERY

San Francisco

Tenancy: the temporary possession of what belongs to another.

Webster's New International Dictionary of the English Language, Second Edition, Unabridged

PREFACE

The Nehalem River flows to within a fifth of a mile of the Pacific, but then turns and runs parallel to it for two miles before joining it. The land between the River and the ocean — the Nehalem Spit — is low-lying, sandy, and constantly changing.

Each year thousands of people visit the Spit and the adjoining town of Manzanita. Their reasons for coming are personal, but if one watches as they leave their cars and stare seaward it is a fair guess, I think, that many are looking to escape illusion and to be reconciled.

The River's Edge

The eastern side of the Spit is bordered by low woods, thickets of Scotch broom, and muddy tidal flats. At one point there is a boat launch, and at another a length of bicycle path, but for the most part the River's edge is little visited.

If the eastern side of the Spit has a distinguishing feature it is forest debris. Many kinds wash down during winter rains, including naturally occurring bank-side growth, slash from industrial forestry, and occasionally large stumps from the cutting of first and early second growth. Almost all of it arrives as the direct or indirect result of clearcutting and the accelerated run-off and erosion that are its by-products.

Like fracking for oil and gas, and like mining by mountaintop removal, clearcutting is an extractive practice that is radically heedless, one that attacks the physical and spiritual health of everything that lives.

Might clearcutting be stopped? Evidence of societal change is mixed and cautionary: a few miles up the Nehalem River, for example, in an area known as God's Valley, the Christian Futures Corporation arranged in 2001 to clearcut one hundred and twenty acres for which it bought the right from the state of Oregon. The tract contained some of the region's last big trees, and since no official appeal could be made of the state's sale, protesters climbed into the threatened trees. One person even managed to stay there for two days, despite being harassed by sheriff's deputies and loggers with bull horns and sirens and strobe lights, and threatened as they cut away all the branches beneath him and all the closely adjoining trees around him. At 2:00 a.m., however, having been denied food and sleep, he fell sixty feet to the ground. Surprisingly, he survived, though with multiple broken bones and a collapsed lung, and unsurprisingly the clearcut proceeded.

More recently, in 2013 the citizens of Rockaway Beach, just south of the Nehalem River's mouth, observed that aerial spraying of herbicide on clearcuts (necessary for replanting) was drifting toward their homes, and later found that the spraying had poisoned their drinking water. When in 2015 these and similar incidents elsewhere were brought to the attention of the state legislature, it did nothing.

Everything on the horizon across the Nehalem River has been clearcut at least twice. "Beyond irony," William Stafford wrote, "is the hard country no one can misjudge."

2

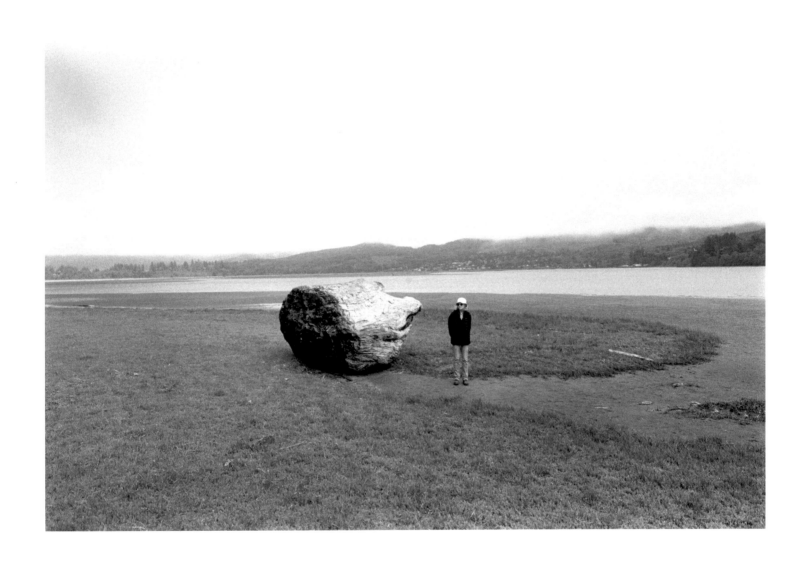

3

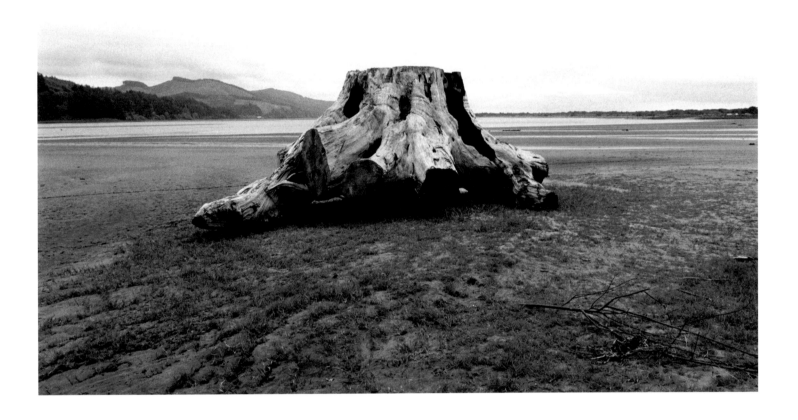

4

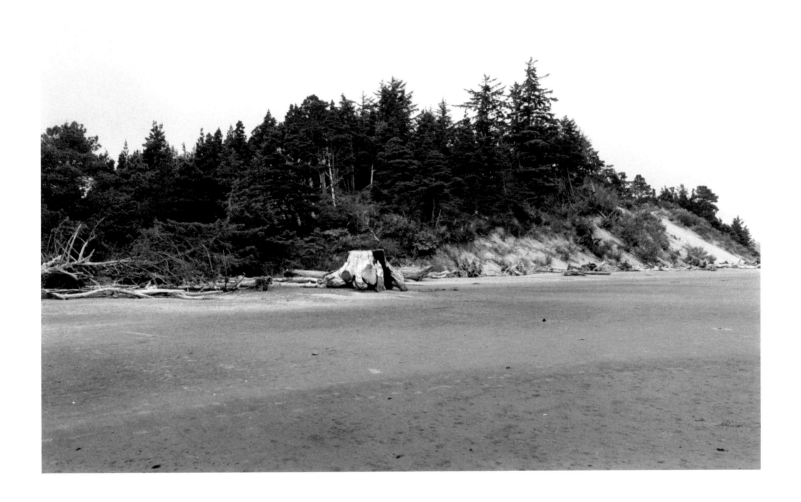

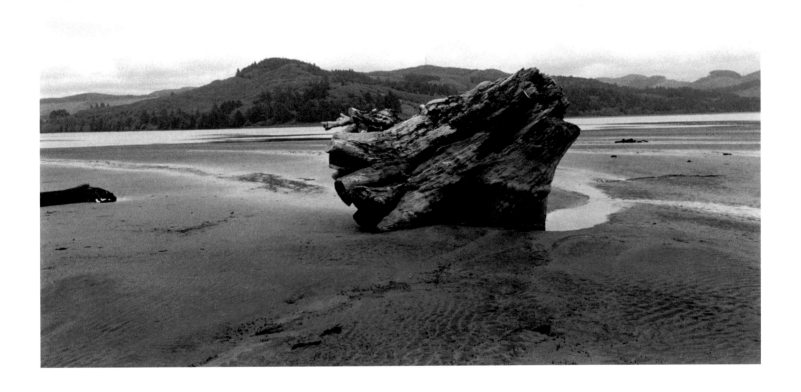

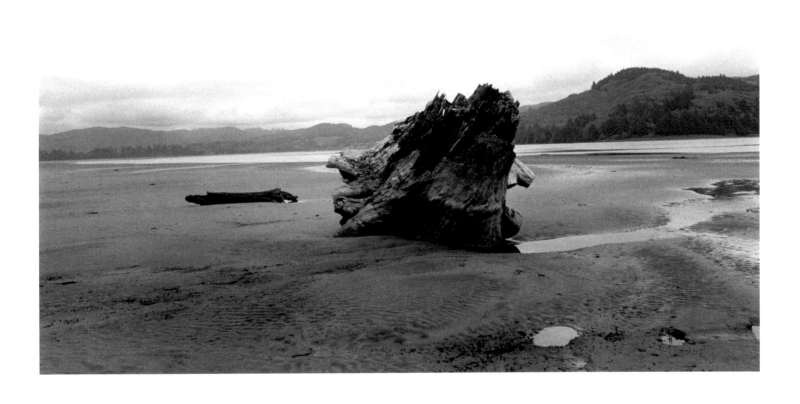

7

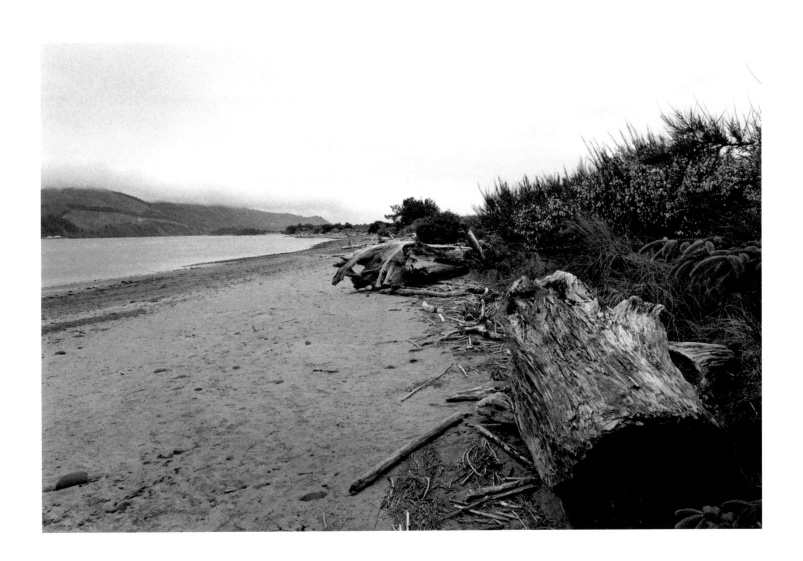

8

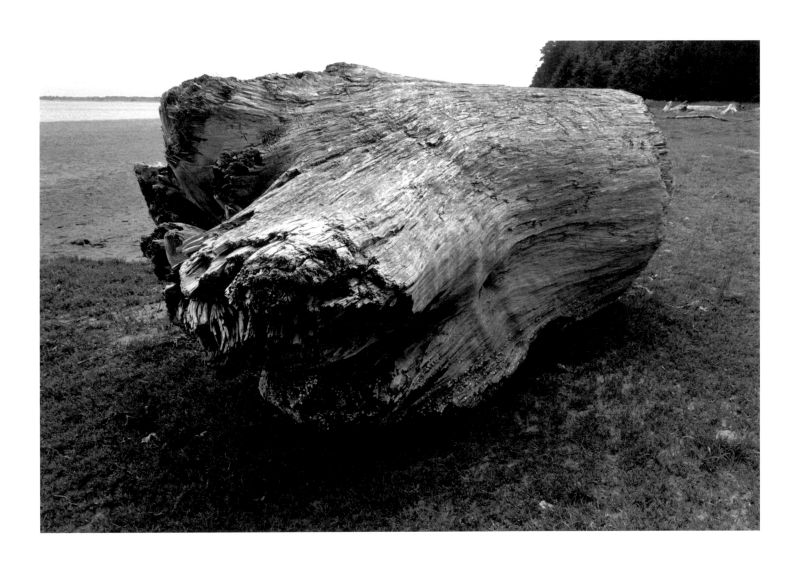

9

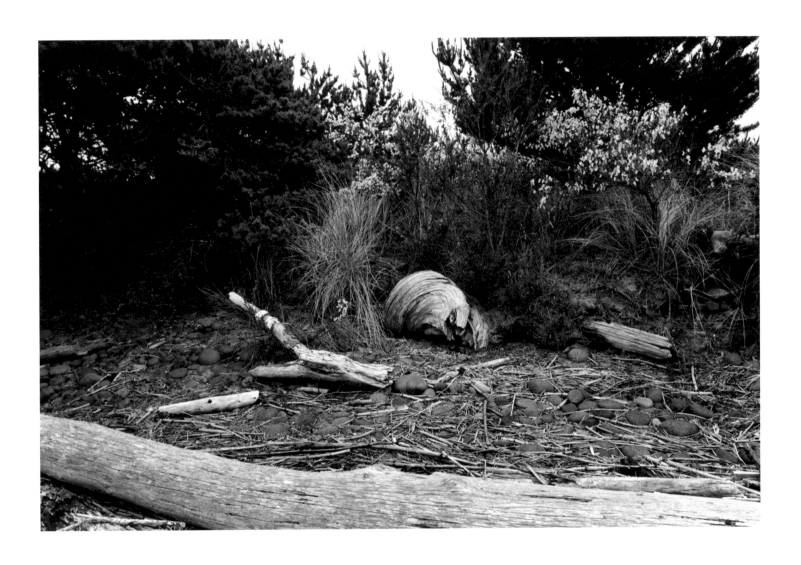

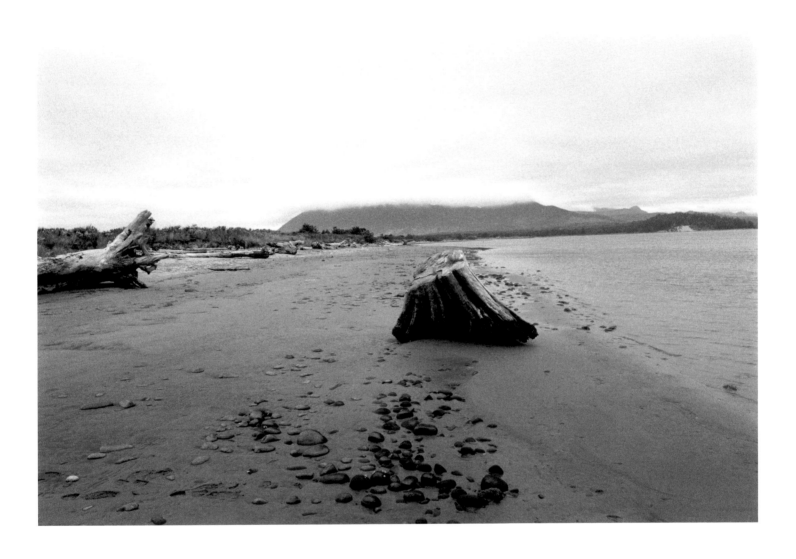

II

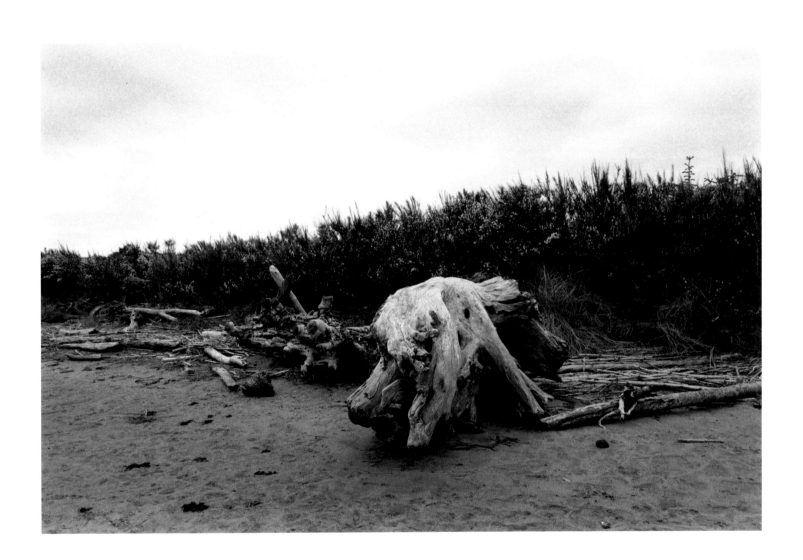

12

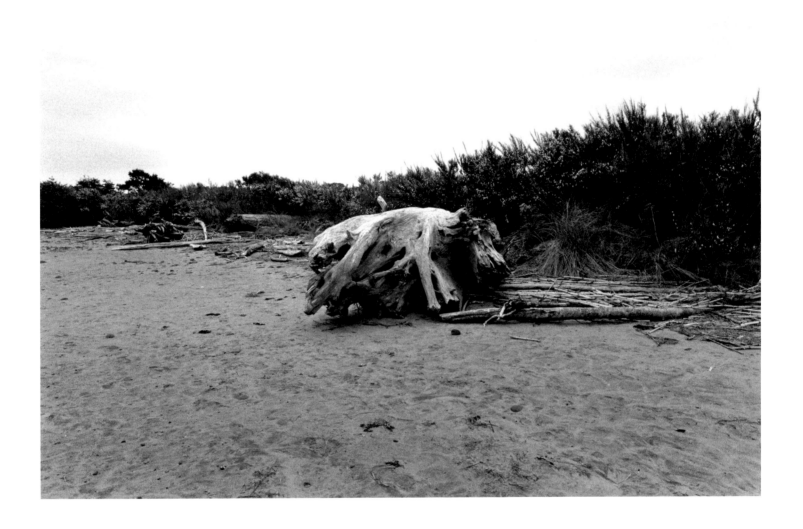

13

The Interior of the Spit

The Nehalem Spit is administered as a state park. It includes a runway for small planes, corrals for horses, paved trails for bicyclists and skateboarders, and two hundred and sixty-five spaces for motor vehicle campers.

South from the campground, accessible only to walkers and horseback riders, are hundreds of acres of small trees, meadows, wetlands, and dunes. It is a relatively exposed landscape, but with qualities of sanctuary.

Against these, however, scientists have in recent times discovered a threat, the Cascadia Subduction Zone, a geologic fault larger even than California's San Andreas fault. Its history establishes that the Northwest Coast will experience, perhaps soon, a magnitude nine earthquake, and with it a tsunami that is projected completely to inundate places like the Spit.

In consequence of that finding there are some who will no longer camp at the Park. Others continue to visit, acknowledging the science but unable or unwilling to do without what they relearn by going there: all the shades of marine light, for example, and the inscriptions of compass grass.

14

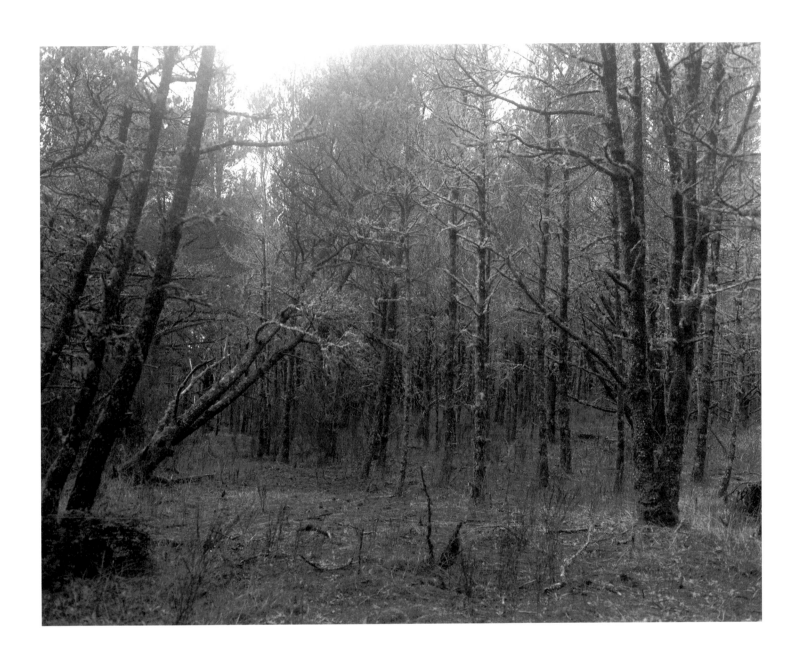

15

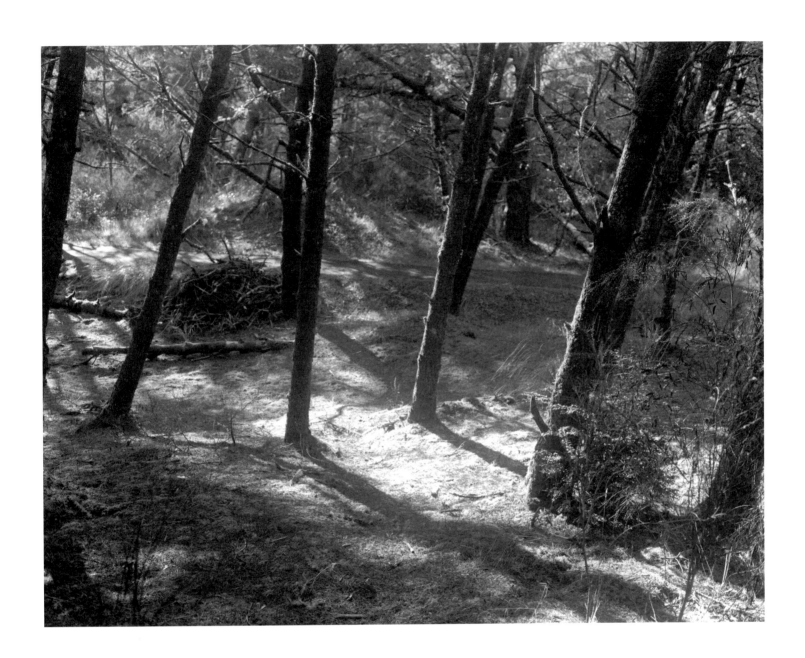

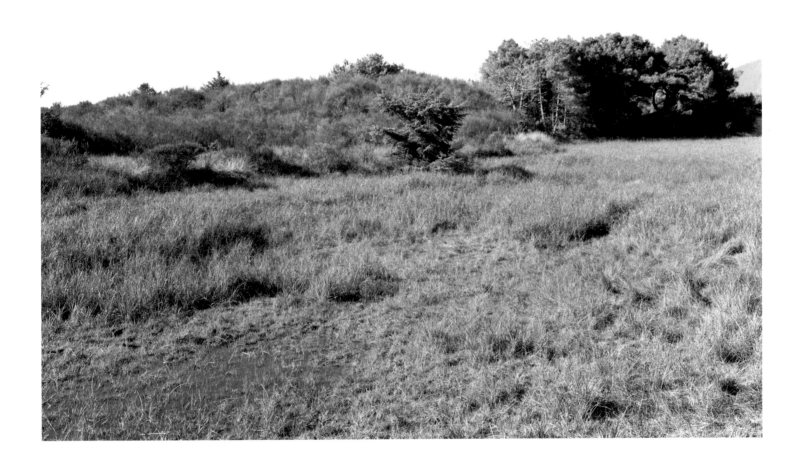

17

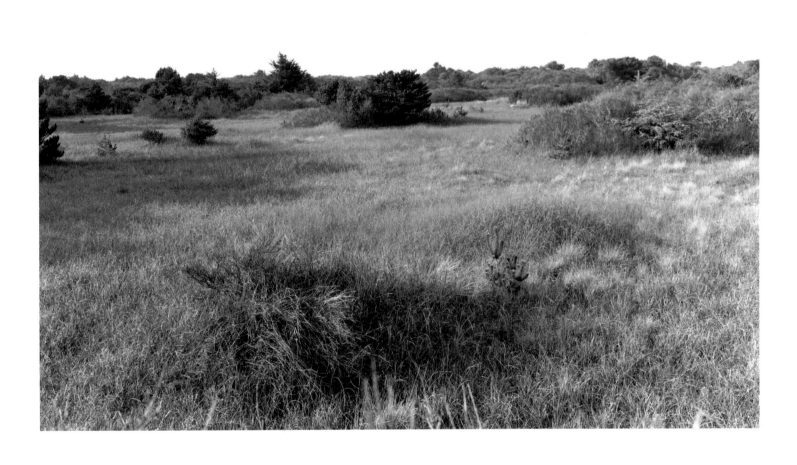

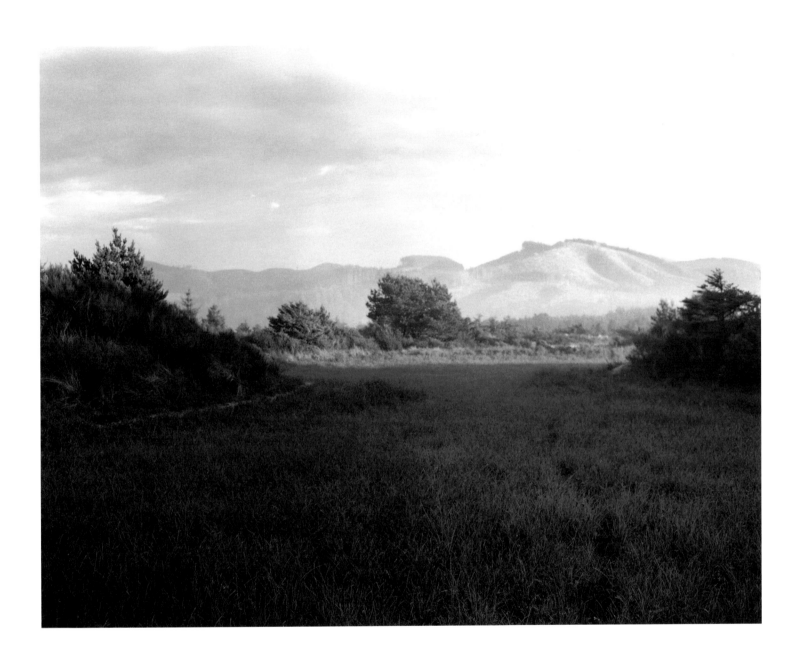

19

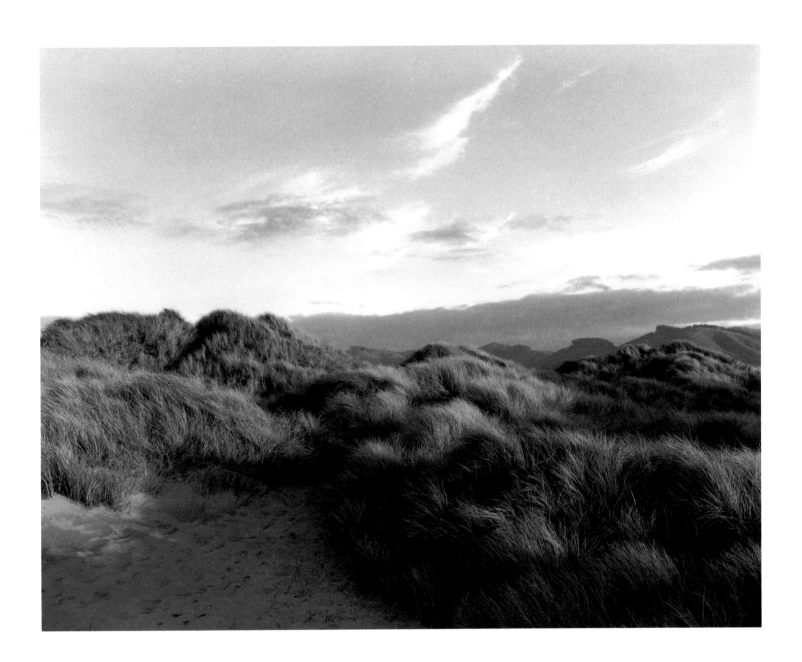

20

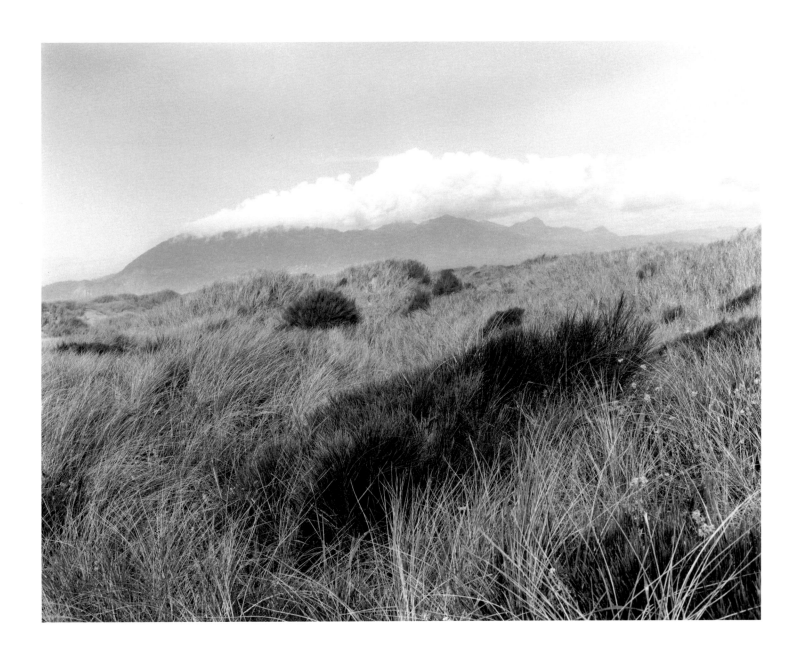

21

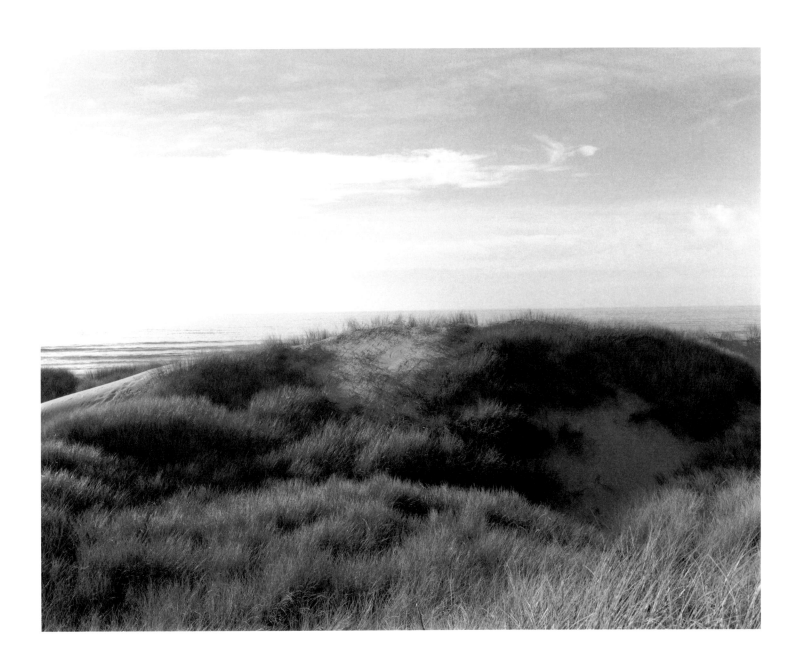

The Sea Beach

In the spring of 2015 walkers on the Spit observed a pair of snowy plovers, a species thought to have abandoned the northern Oregon coast because of habitat loss. As a result the Department of Fish and Wildlife determined that portions of the beach should be placed off-limits to walkers during the birds' nesting season, and although the restriction was inconvenient and although the area was unpatrolled, most people complied.

Emily Dickinson famously likened hope to a bird. It sang, she wrote, "in the chillest land / And on the strangest Sea."

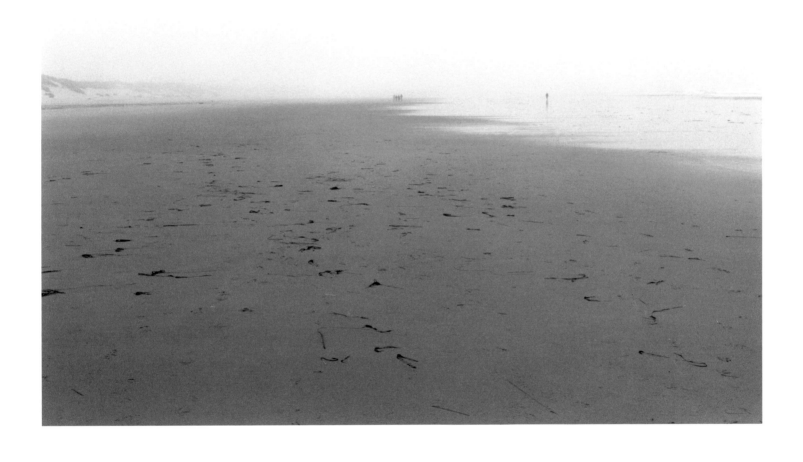

23

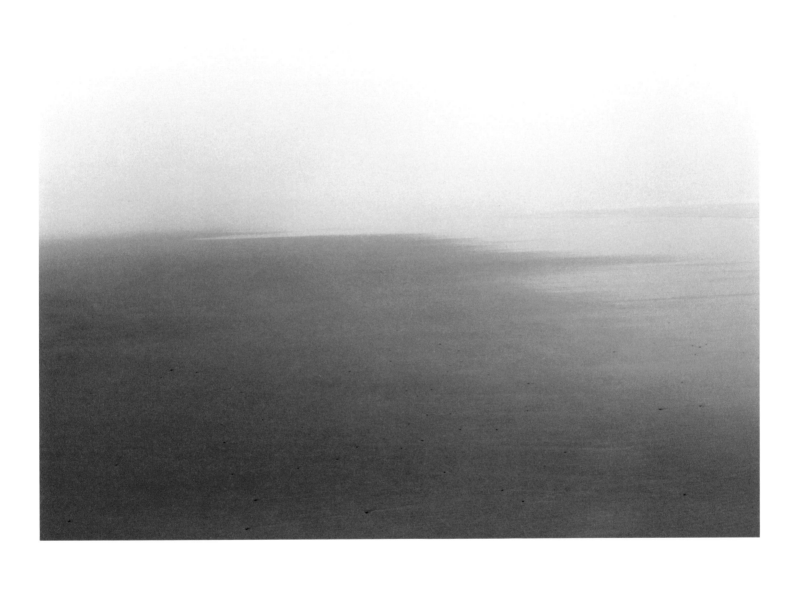

24

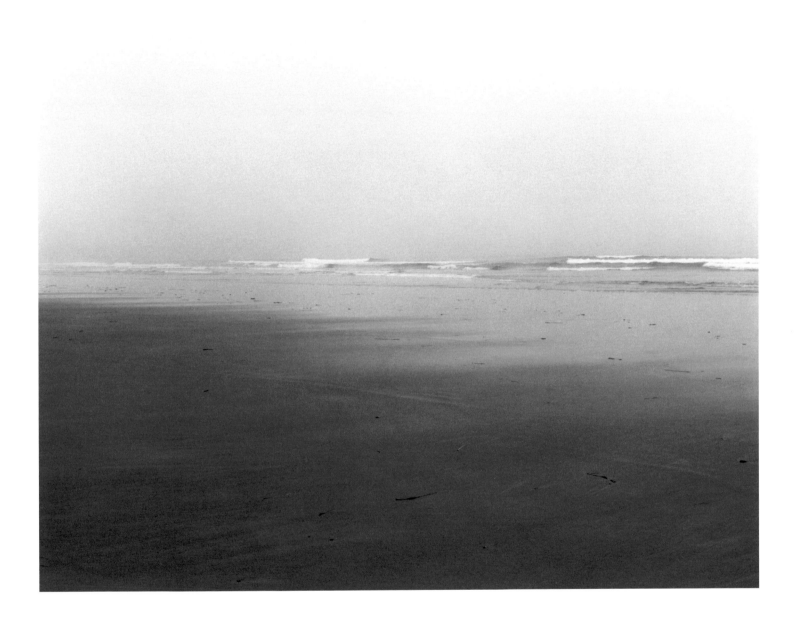

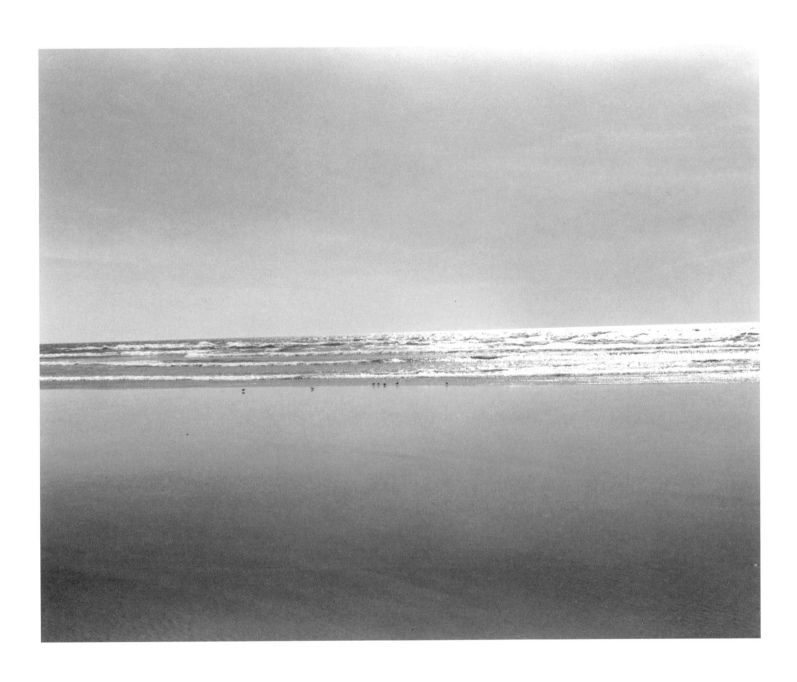

26

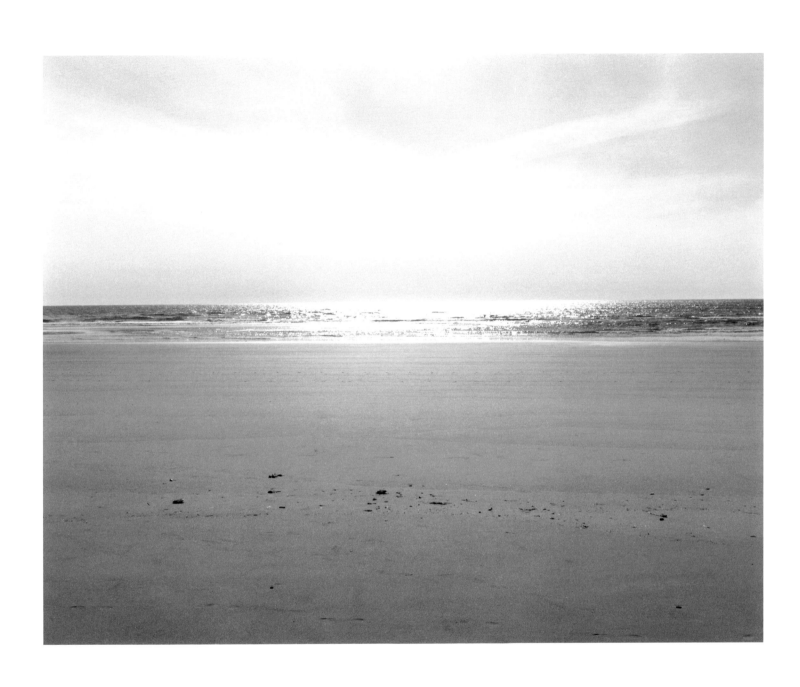

27

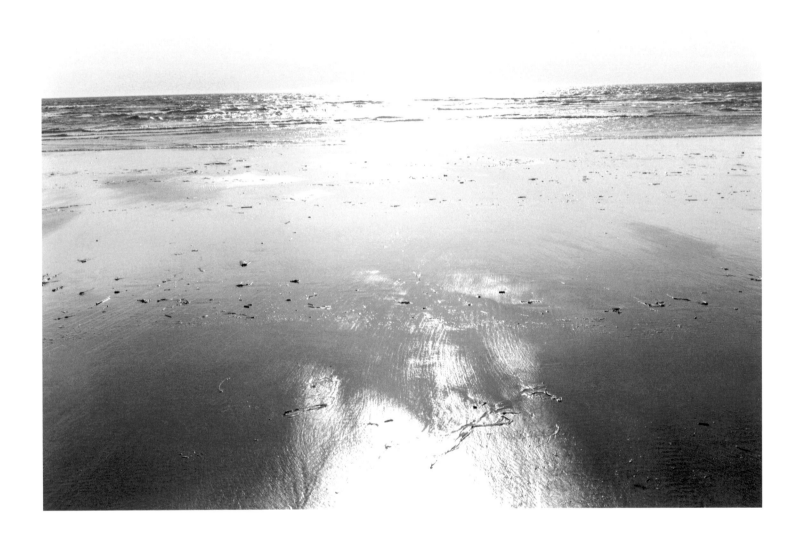

28

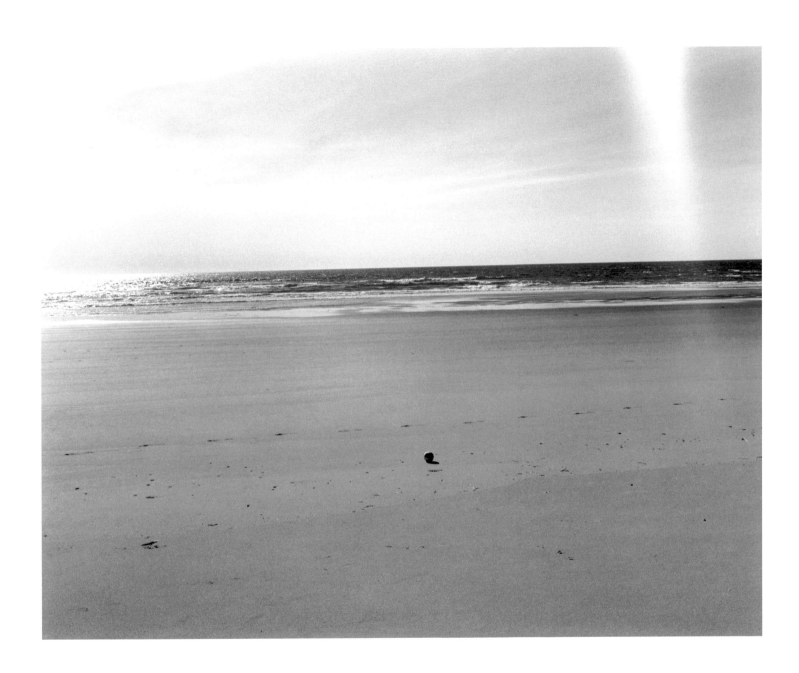

29

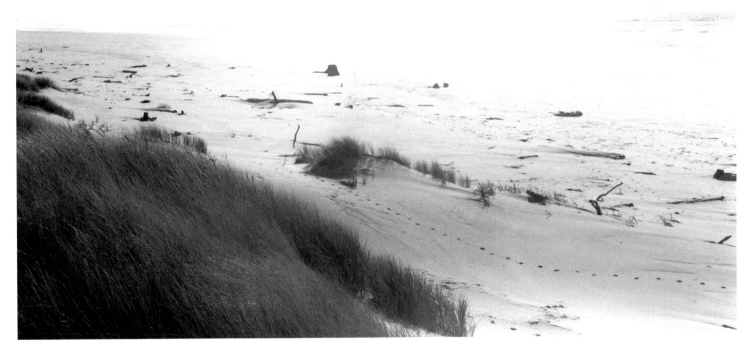

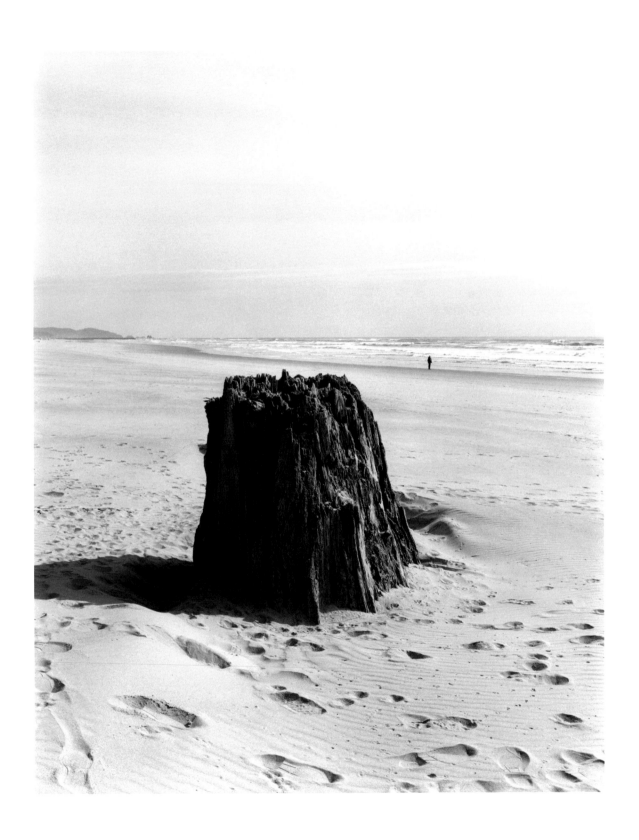

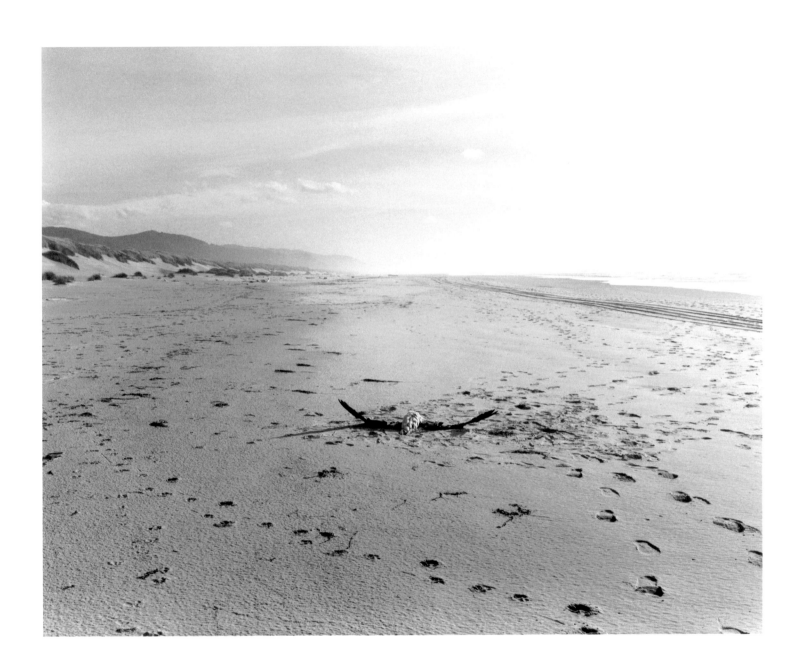

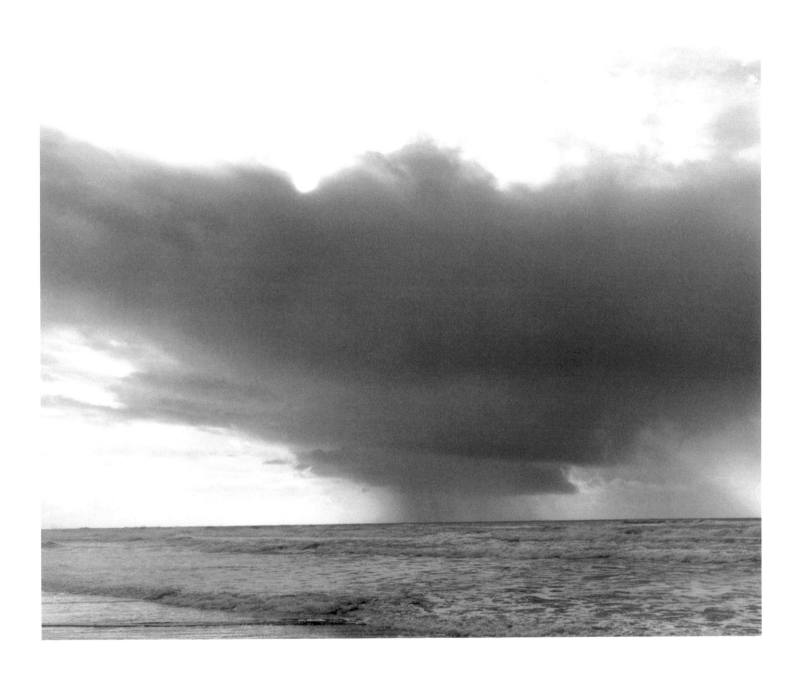

33

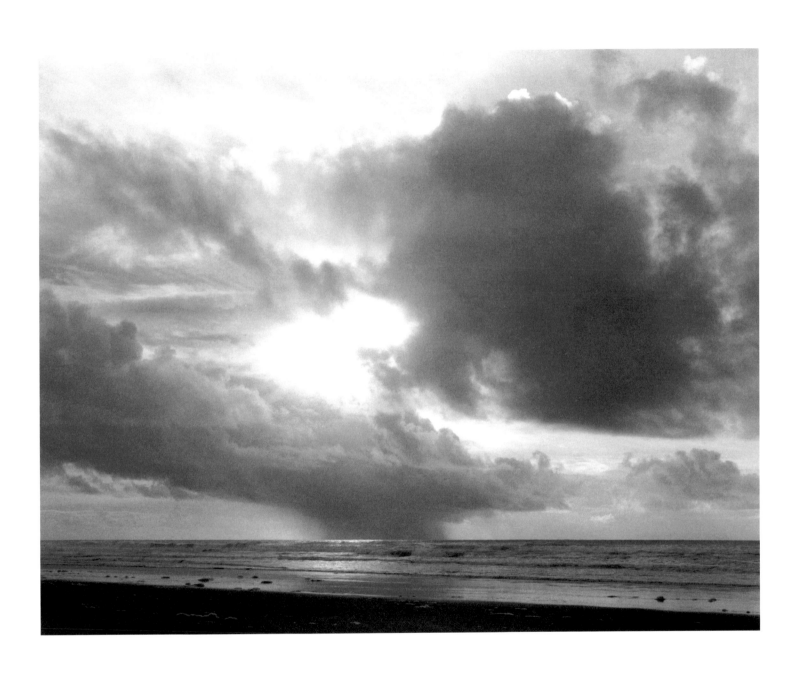

34

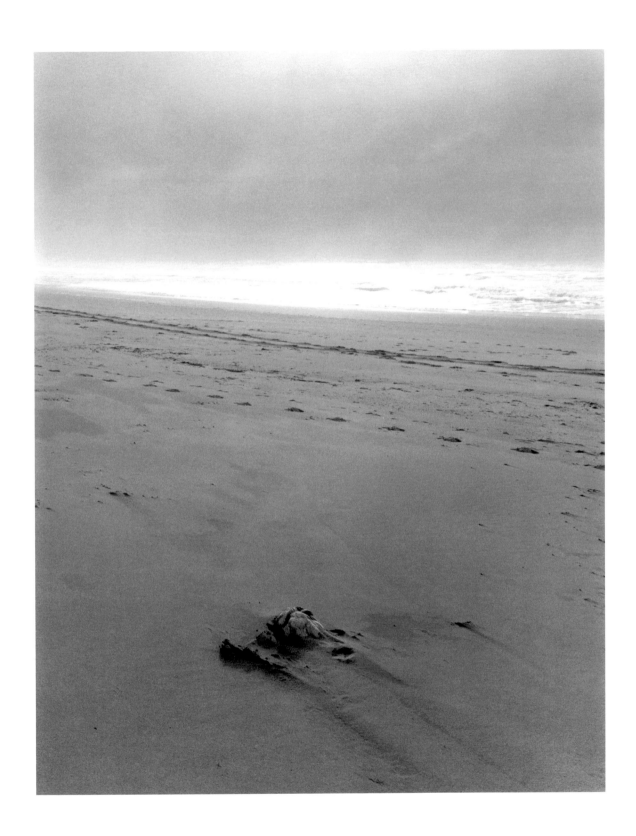

35

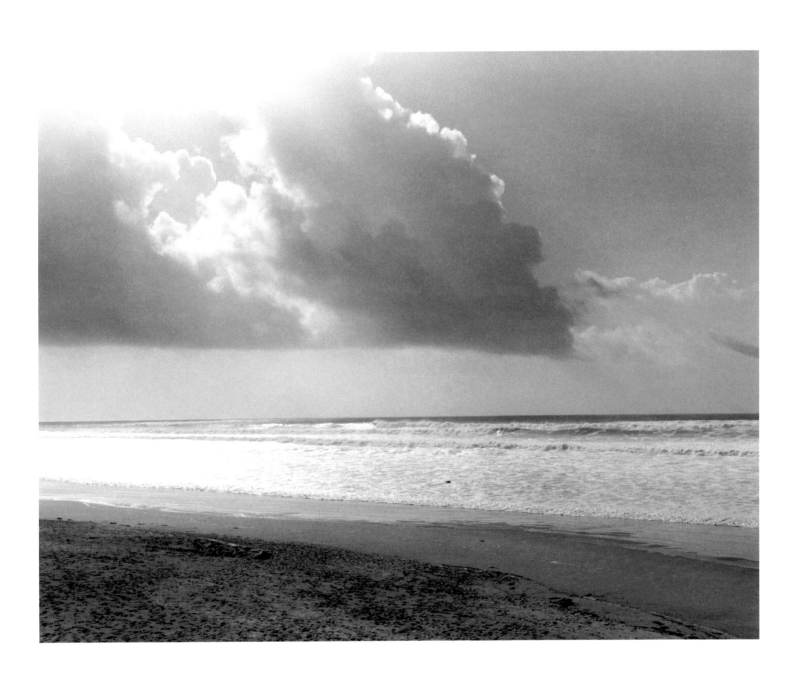

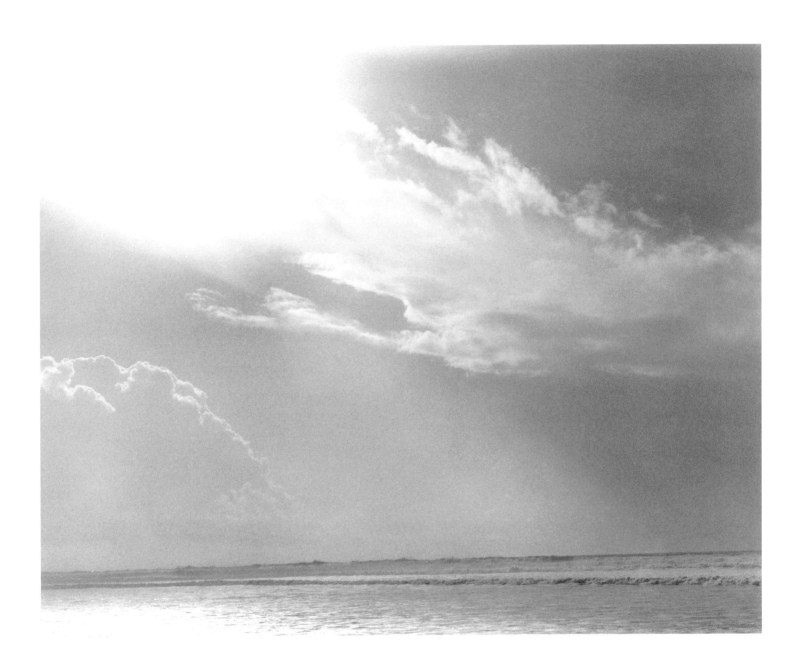

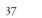

37

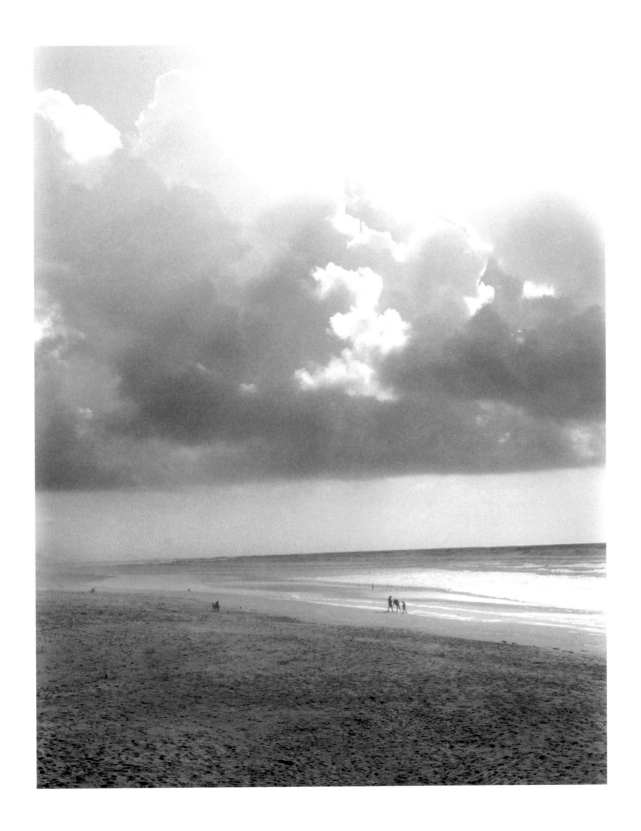

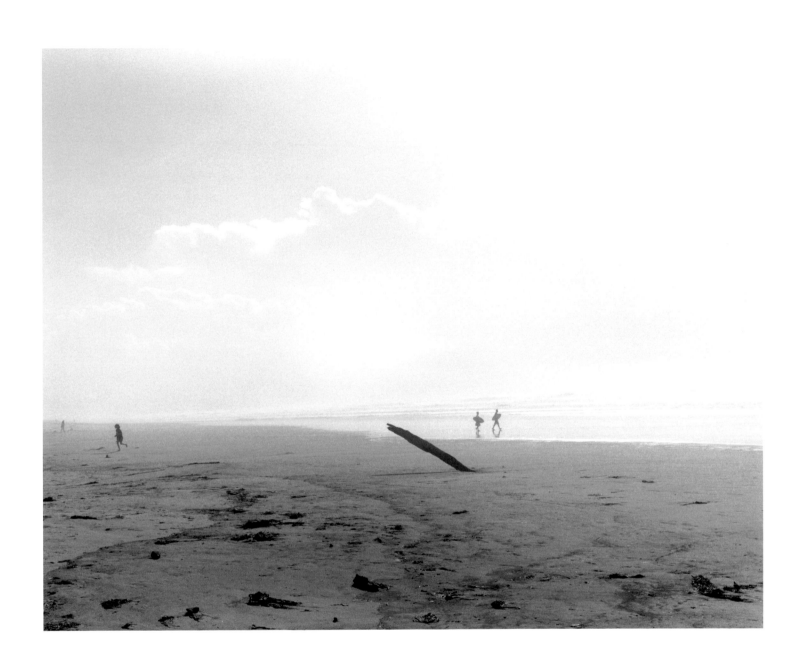

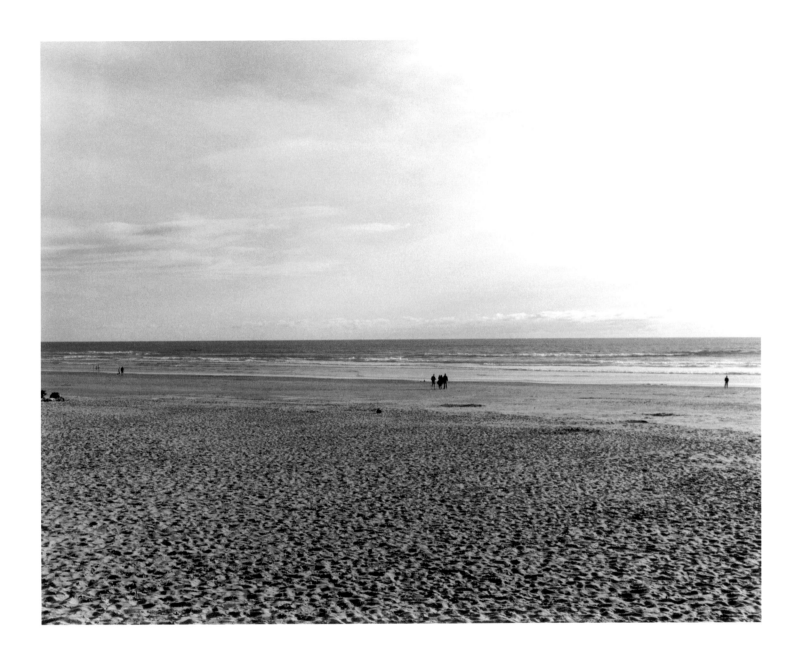

40

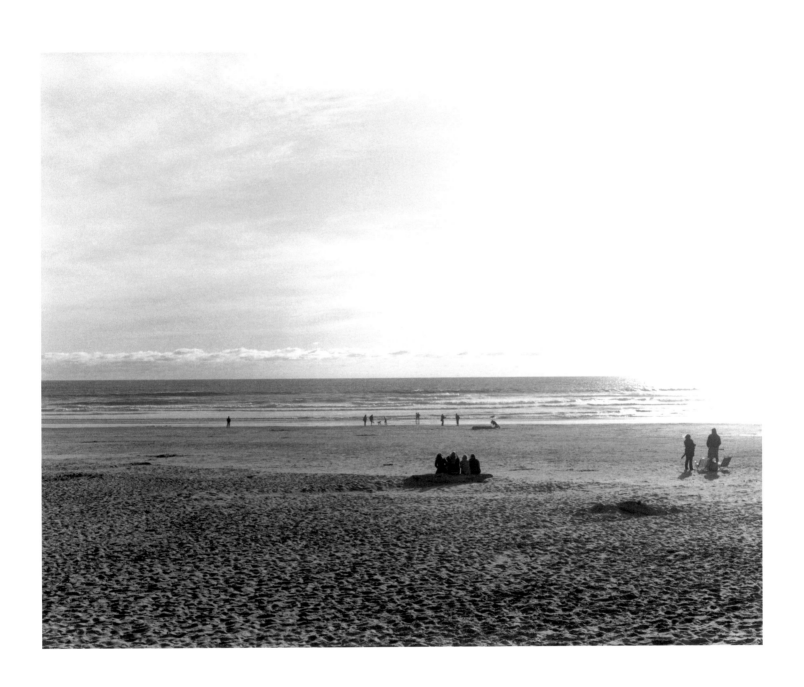

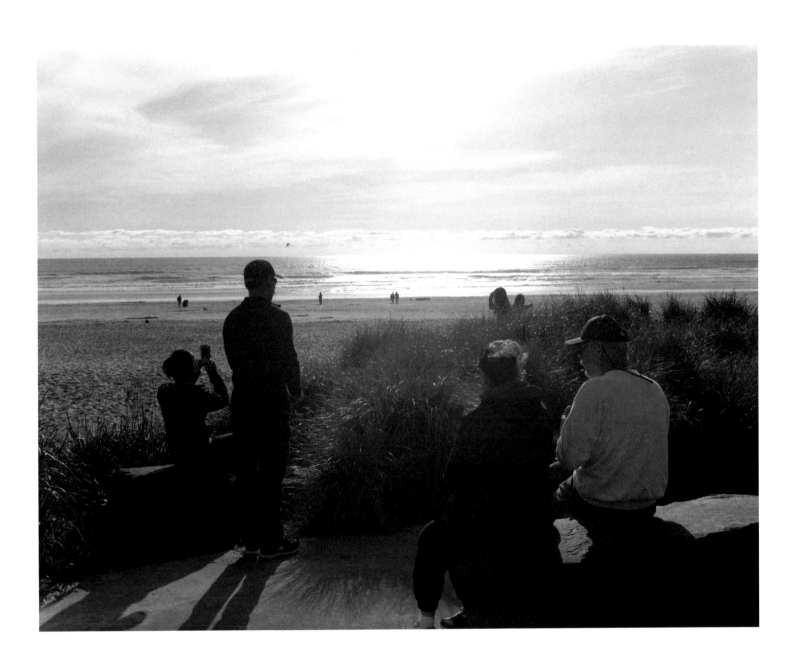

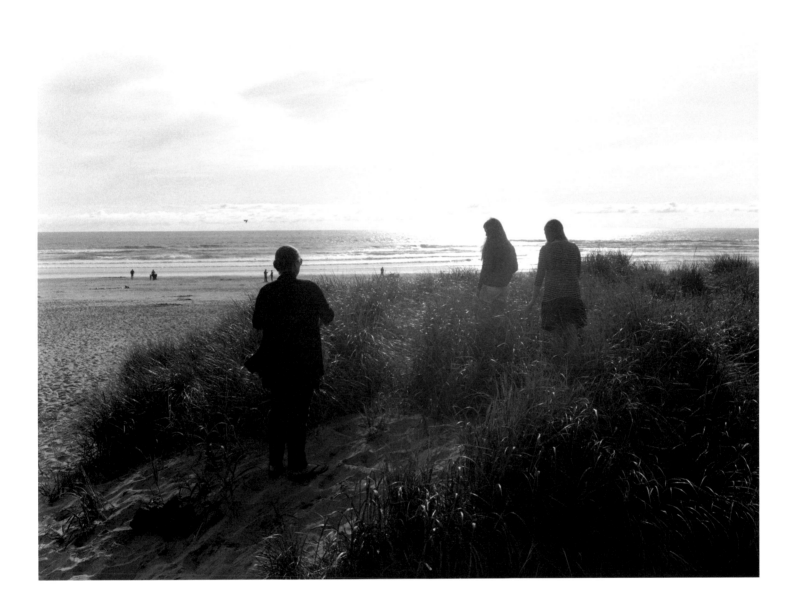

. . . the sun goes down in waves of ether

in such a way that I can't tell

if the day is ending, or the world,

or if the secret of secrets is within me again.

Anna Akhmatova
Translated by Jane Kenyon

43

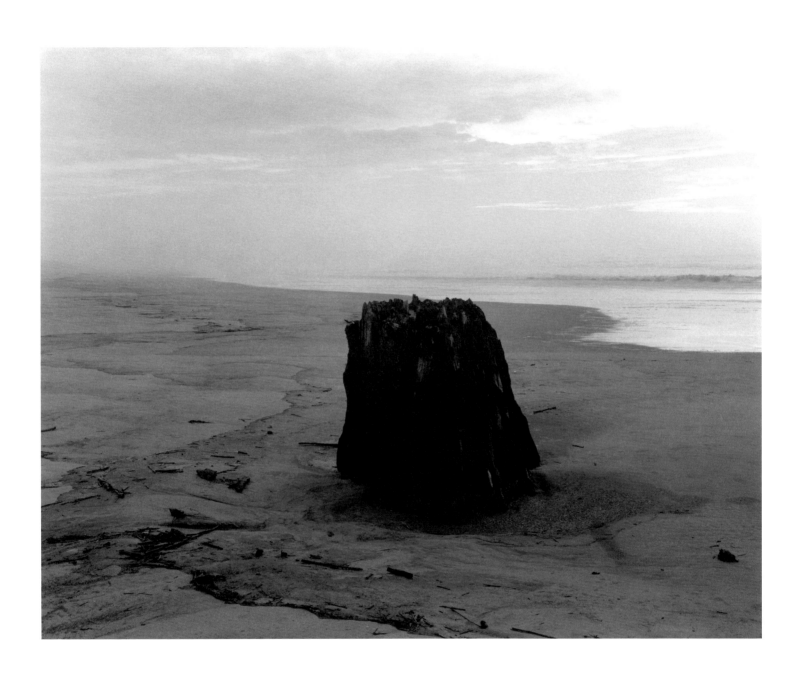

TENANCY: BETWEEN THE RIVER AND THE SEA

The picture preceding the title page was made northeast of Oregon's Nehalem Bay State Park.
All other pictures were made inside the Park or in Manzanita between 2013 and 2015.

The excerpt from Anna Akhmatova's poem "On the Road," translated by Jane Kenyon,
comes from *Jane Kenyon: Collected Poems*, copyright © 2005 by The Estate of Jane Kenyon.
It is reprinted with the permission of The Permissions Company, Inc.,
on behalf of Graywolf Press, www.graywolfpress.org.

ISBN: 978-1-881337-45-4

Design: Katy Homans
Coordination: Ola Dlugosz, Torin Stephens, Graham Austin
Tritone separations: Thomas Palmer
Printing: Meridian Printing under the supervision of Daniel Frank

FRAENKEL GALLERY

49 Geary Street, San Francisco, CA 94108
415.981.2661
www.fraenkelgallery.com

Plate 28: A plastic ball from Japan (lens flare, right)
Plate 31: An albatross
Plate 34: The albatross after two days of storms

The book would have been impossible without the loyalty and caring of Jeffrey Fraenkel,
Frish Brandt, the staff at Fraenkel Gallery, Thomas Palmer, Katy Homans,
and Daniel Frank and the staff at Meridian Printing.
Kerstin and I have been fortunate far beyond deserving.